Watercolour Techni Workbook

Bob Erends

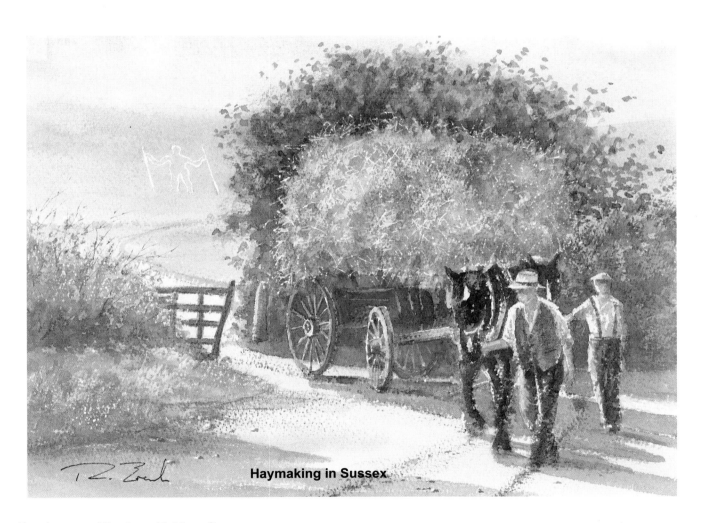

Haymaking in Sussex

Front cover: **Stopham Bridge, Sussex**

This is a practical workbook which is designed to encourage you to use your paints and brushes to practise the exercises contained herein.

Landscape Elements

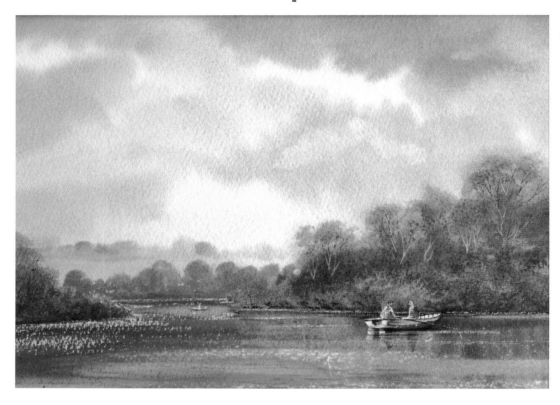

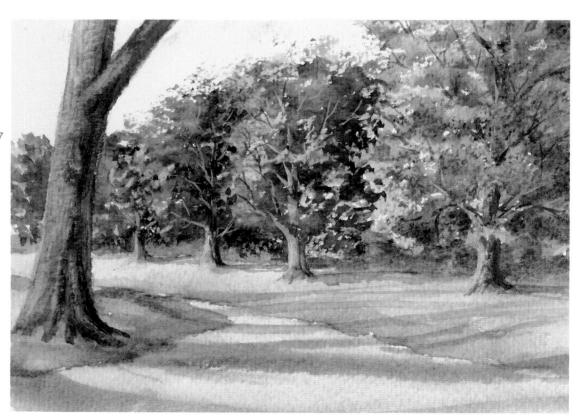

Landscape Elements

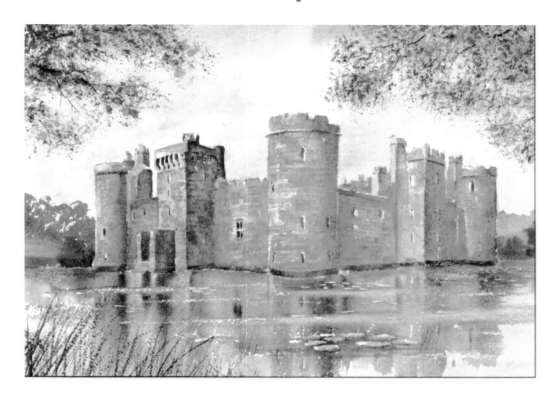

Techniques for painting

WATER

Pages 28 - 39

Techniques for painting

SHADOWS

Pages 40 - 61

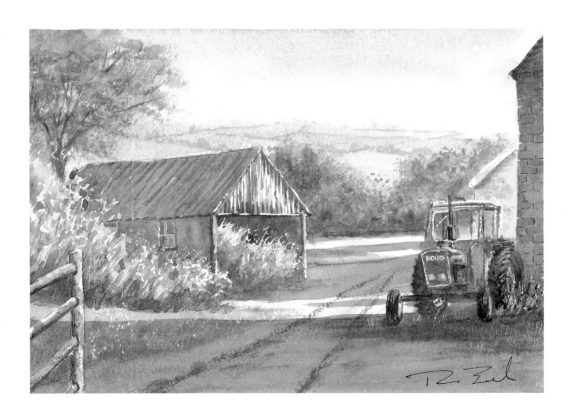

Bob Erends is a professional artist who specialises in the medium of watercolour. He is a professional associate member and demonstrator for the SAA .

He is a demonstrator for St. Cuthberts Mill, manufacturers of Bockingford and Saunders Waterford Watercolour Paper, and also for Pro Arte brushes.

In addition to teaching at art centres, colleges and his own studio in Sussex, he gives tutorials and demonstrates to art clubs, organisations and on various cruises. He has contributed to art magazines.

He has held in excess of 20 solo exhibitions throughout Sussex, Kent and London. His paintings are in collections worldwide.

His love and concern for the countryside is evident in many of his paintings.

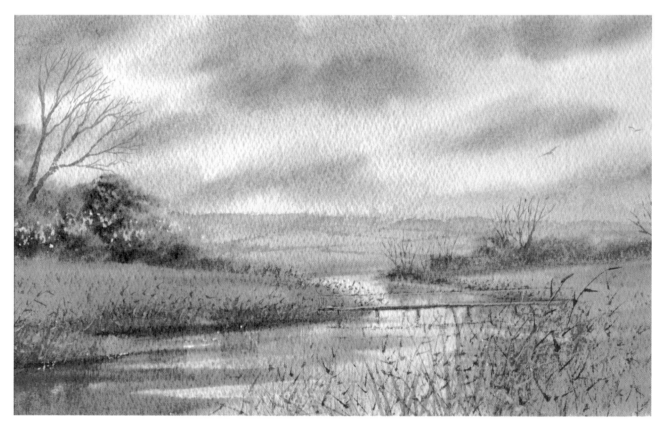

Snaylham, Brede Valley, East Sussex

DEDICATION

To my wife 'Kath' and Family for their support and to my friend and fellow painter John Glen for his valuable help and encouragement without which this book would not have been possible.

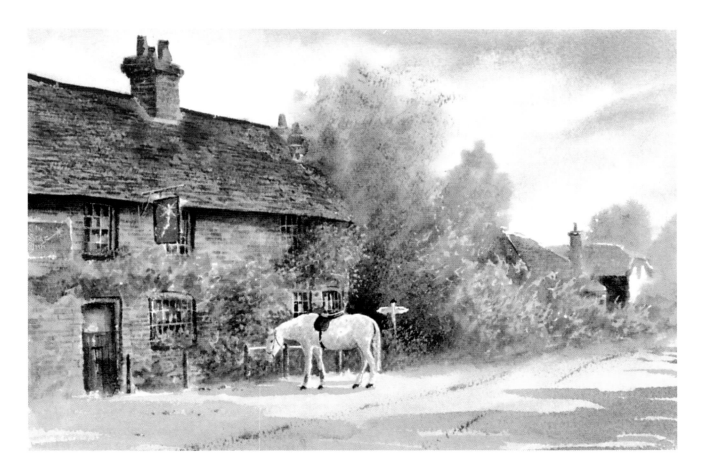

Star Inn, Waldron, Sussex

First published by Bob Erends in Great Britain 2005

Layout and design: Bob Erends and John Glen

Printed by Hastings Printing Company Ltd, Hastings
Drury Lane, St. Leonards-on-Sea, East Sussex. TN38 9BJ

6

Contents

INTRODUCTION

How often have you admired a painting and wondered how the artist produced the result which caught your imagination?

How often has a picture, or an element within it, aroused the desire in you to emulate the effects achieved by the artist?

How often have you said to yourself, *"If only I knew how to produce that particular effect."*

If only!

I have written this workbook to help and encourage the understanding of, and active participation in, the techniques which enable us to improve the realism, impact and drama in our pictures.

Many of the paintings you see rely, in some significant measure, upon the types of techniques which I reveal in this book. Do not conclude from my comments that attractive, successful pictures depend entirely upon techniques. The artist's own style and inspiration are vital factors which may be supported to some degree by brushwork underpinned by techniques.

I will reveal how dull uninteresting pictures can be avoided by means of simple uncomplicated brush work.

Fig. 1 River Cuckmere, near Alfriston, Sussex

Materials & Equipment for Watercolour Painting

The huge range of art materials available on the market inevitably means that there is no absolute right or wrong choice for us as individuals. It is, perhaps, advisable to build up your requirements as your art develops. As a guide I list below the materials I use.

GENERAL ITEMS

A table or free standing metal easel capable of adjustment from the horizontal to various angled elevations.

A board (eg plywood) to support the watercolour paper. Soft lead pencils grades 2B, 4B and 6B.

A soft rubber eraser (not a putty rubber),

Piece of natural sponge with open texture.

Masking Fluid (grey PEBEO) and a ruling pen to apply the fluid.

¾ inch masking tape to secure the watercolour paper to the board.

PAPER AND BRUSHES

Paper - Bockingford 200lb paper with a rough or medium texture. (The latter is known as having a NOT surface).

NB All paintings in this book were painted on Bockingford 200lb rough surface paper.

Brushes - I use Series 100 Pro Arte round brushes Nos. 8, 10, 14,16,18 and Series 103 Rigger brushes Nos. 1,2 and 3.

In addition I use an extra large Series 50 Pro Arte wash brush principally for skies. A ¾ inch flat brush is useful for lifting out paint in water areas of paintings.

PAINT

I prefer to use Winsor & Newton Artist quality tubed paints. There is no need to have a large number of colours: I find that in the main the undermentioned colours are very suitable for the great majority of my paintings. These colours are squeezed out into the small compartments of a large palette.
I use a 'Jakar' 18 compartment palette which also provides 5 paint mixing areas.

Cobalt Blue
French Ultramarine Blue
Cerulean Blue
Light Red
Permanent Rose
Burnt Sienna
Raw Sienna
Winsor Yellow
Naples Yellow

Mixing Watercolour Paints

Throughout this book I specify the nature (consistency) of the colour washes and mixes that are to be used to produce the desired effect at any given stage. It is important to observe the instructions in order to avoid disappointment with the resultant outcome.

The **consistency** of a mix or wash is dependent upon the **amount of water** used. For the purposes of this book I have confined the types of mix and wash to the three basic classifications shown below.

CONSISTENCIES:

FLUID - a very watery mix which flows easily.

MEDIUM- still a watery mix but with significantly less water than in a fluid mix.

DRYISH - very little water used, resulting in a slightly stiffish but paintable consistency.

You may wonder why different consistency mixes are necessary.

Figure 1 illustrates the effect of using two fluid consistency applications of colour wet in wet. The first application was a fluid consistency wash of Cobalt Blue. The second involved a fluid consistency mix of Cobalt Blue + Light Red which was painted on top of the Cobalt Blue wash.

Figure 2 shows the same colours with differing consistency mixes, namely, a fluid consistency wash of Cobalt Blue as before followed this time by a medium consistency mix of Cobalt Blue and Light Red.

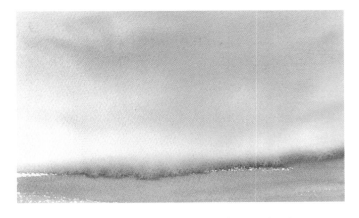

Incorrect ie not the result required

Fig. 1

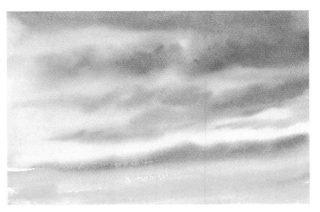

Correct ie the required effect sought

Fig. 2

In Fig. 1 the two fluid consistencies have broadly merged into a single colour with a consequent loss of control for the artist to influence the outcome of the double application. Whereas in Fig. 2 there is a clear demarcation between the two differing consistency applications and this has enabled the artist to exercise a measure of control on the resultant effect thus achieving the soft edges desired.

Skies

INTRODUCTION

Skies are a very important element of our paintings and can comprise as much as two thirds of a picture.

They are so influential in that they can affect and determine the mood and style of a picture. As such they are a significant component of our landscape paintings consequently we are faced with the need to represent them in a believable way to viewers.

In my experience it is essential to paint skies quickly and fluently, in doing so avoid meticulous fussy brushwork. To that end it is necessary to develop ways and means, i.e. techniques, for achieving the twin goals of realistic skies and fluent brushwork.

In the box headed 'Sky Tips' I have listed some aids which together constitute techniques which I have found most useful in overcoming the many pitfalls which await the unwary painter of skies. I suggest you spend time studying the Tips and bear them in mind when you come to that moment of having to cover a significant portion of your paper with sky colours.

SKY TIPS

1. Always mix enough paint to cover the area of sky to be painted.

2. If painting wet-in-wet always prepare colour mixes prior to dampening the paper.

3. Never mix more than three colours together in a single mix. To do so will produce mud! (a non-transparent colour or tone).

4. Dampening the sky area of the paper prior to painting provides a longer working time and aids the creation of soft edges by virtue of painting wet-in-wet.

5. If the sky area has been dampened with water prior to painting, allow time for the paper to absorb some of the water (at least one minute) before actual painting is commenced.

6. Always use a large soft wash brush to apply the colour.

7. Always work quickly using as few brush strokes as possible.

8. As a general rule (and to create perspective) make the sky darker at the top and weaker in tone nearer the horizon.

9. To create perspective and depth, clouds should be larger and more massed at the top of the painting and smaller and flatter towards the horizon.

10. Never divide a landscape picture area equally between sky and land.

11. Fussy/busy skies need plain calm landscapes and vice versa.

I cannot emphasise too strongly the need to practice the various approaches outlined herein. Treat them as a stepping stone towards developing your own styles and procedures in conjunction with your colour preferences.

Let us consider some ways and means of painting skies.

Heavily overcast Sky

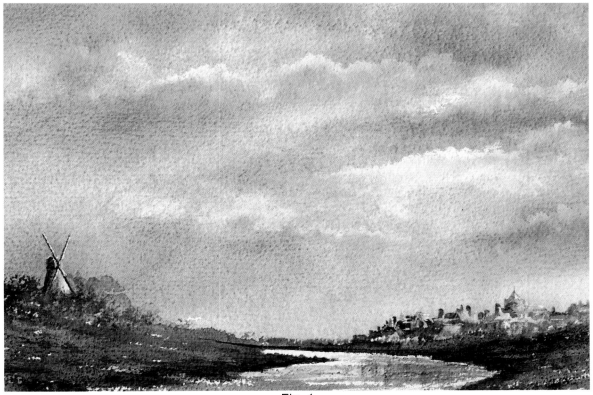

Fig. 1

This is the first of the techniques which I suggest you try for yourself: it involves a very limited palette. Having produced a pencil sketch of the scene, prepare:

1) Fluid consistency wash of Cobalt Blue.
2) Medium consistency mix of Burnt Sienna + French Ultramarine Blue (grey).
3) Dryish consistency wash of White Gouache.

Using an extra large wash brush, dampen the sky area of the paper with clean water. This should be left long enough for the paper to absorb some of the moisture, i.e. something of the order of at least 60 seconds.

Starting at the top of the paper apply wash 1) using single horizontal strokes with an extra large wash brush across the paper down to the horizon line. Paint over the distant buildings on the right hand side of the picture.

With the same brush drop in mix 2) here and there into areas of the sky making sure that the massed darker cloud is towards the top of the painting. Allow the sky to dry before using a No. 12 brush to add touches of wash 3) to highlight some upper cloud areas, then immediately soften the lower painted edges with a damp brush. Dry off the painting.

Use the same brush with mix 2) to paint in the angular shapes of the buildings, including the windmill and both river banks. Paint over areas of the water with wash 1) then dry off all paint.

Finally add a few highlights in the buildings and windmill using wash 3).

NB1. Mix 2) may need to be darkened in tone by adding more of each colour prior to painting the buildings and river banks.

NB2. I seldom use "Designers white Gouache" as it is opaque. In this book I have confined its use to a couple of exercises to give you an insight as to its effectiveness in appropriate circumstances.

Single colour Sky

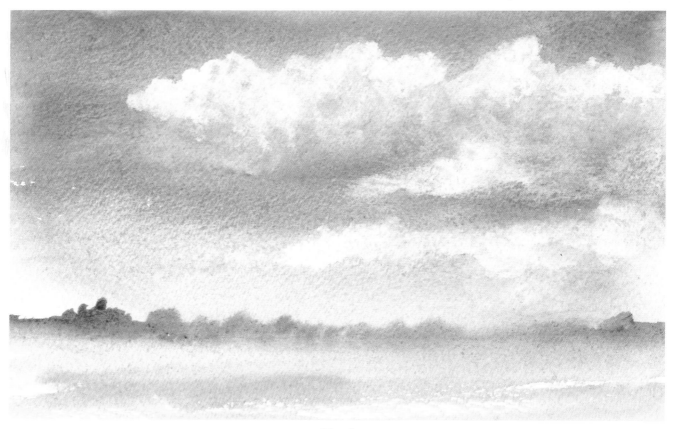

Fig. 2

Only one colour, namely, Cobalt Blue is used to produce the sky effect shown in Fig. 2.

Start by preparing a fluid consistency wash of the colour , then use an extra large wash brush to dampen the sky area of the picture with clean water. Remember to allow time for the paper to absorb some of the moisture.

With an extra large wash brush apply the colour to the damp paper starting at the top using single horizontal brush strokes across the whole width of the paper. Gradually reduce the tonal density of the colour towards the horizon.

Before the paint has time to dry use a small dry piece of tissue paper to lift out the colour from those areas in which you want the upper parts of the clouds to appear. In doing this make sure that you apply clean parts of the tissue at all times.

Follow on by using a piece of damp tissue, from which all the water has been squeezed, to blot out more colour in the lower parts of the clouds.

This has the effect of creating subtle shadows in those areas as the damp tissue does not lift out the colour entirely.

Early morning - Late evening Sky

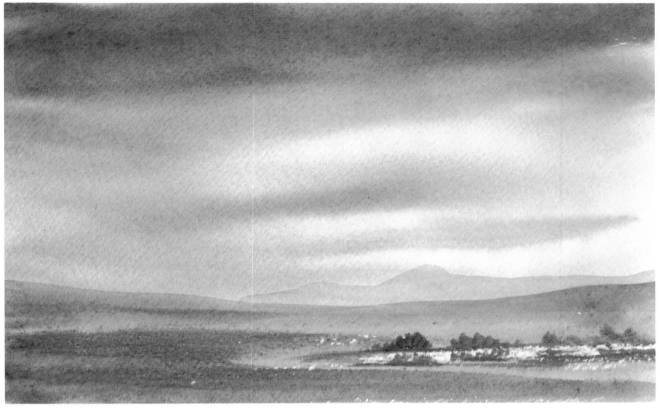

Fig. 3

This is an example of a sky being created using the wet-in-wet technique for the application of all the colours concerned at all stages of the total process.

Note that an extra large wash brush should be used to paint this sky.

Start by preparing:

 1) Fluid consistency mix of Naples Yellow and Permanent Rose. (reddish orange)
 2) Medium consistency mix of French Ultramarine Blue, Light Red and Permanent Rose. (purple/grey)

Dampen the sky area with clear water and allow time for moisture absorption by the paper before painting. Apply varying tonal shades of mix 1) to the lower areas of the sky. Apply the second mix, in doing so use horizontal brush strokes from left to right ensuring that the darkest tones of colour are in the upper sky area.

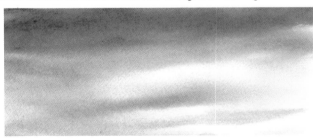

Note the tonal changes from the upper sky down to the horizon.

Cloudy Sky

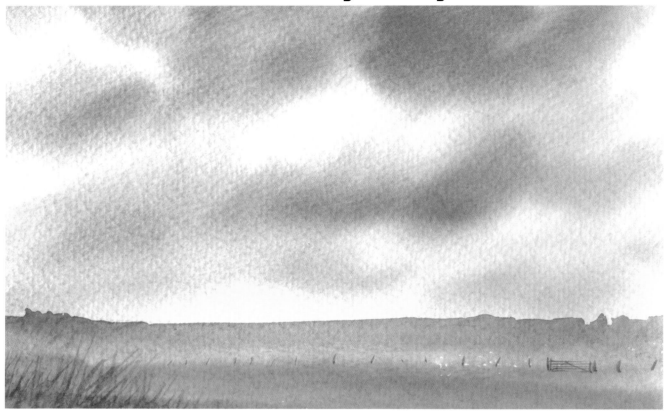

Fig. 4

This sky relies upon the wet-in-wet technique in order to provide soft edged clouds.

Once again prepare the required washes and mixes prior to any application of paint. In this instance the following are needed:

1) Fluid consistency wash of Naples Yellow.
2) Medium consistency wash of Cobalt Blue.
3) Medium consistency mix of French Ultramarine Blue and Light Red (grey).

Use an extra large wash brush to dampen the paper over the sky area with clean water. Allow time for the paper to absorb some of the water. Then using the same brush apply wash 1) over random areas of the sky immediately followed by wash 2) in similar fashion.

Finally use mix 3) to depict darker clouds taking care to leave light areas of sky.

Note that each of the second and third applications of colour are applied while the previous paint is still damp, thus ensuring subtle soft shadings of colour.

Single Colour Sky painted on Dry Paper

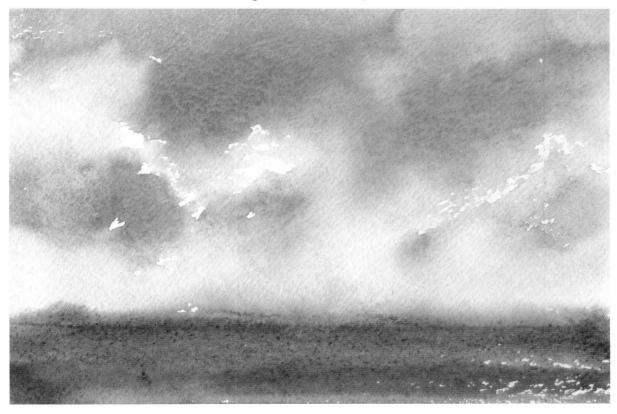

Fig. 5

By way of a change the sky in Fig. 5 relies upon colour being applied to dry paper and as such provides us with an alternative method for painting skies.

Use an extra large wash brush to apply a fluid consistency wash of Cobalt Blue in random fashion in the sky area taking care to leave unpainted areas.

Immediately rinse the brush in clean water and use it to soften some, but not all, of the blue edges, this needs to be done quickly in order to achieve the desired soft effect.

Note that some hard edges of white paper remain.

In spite of painting on dry paper it is possible to achieve soft contours to clouds. The small hard white gaps in the colour add significant realism to the overall effect.

Graduated Sky

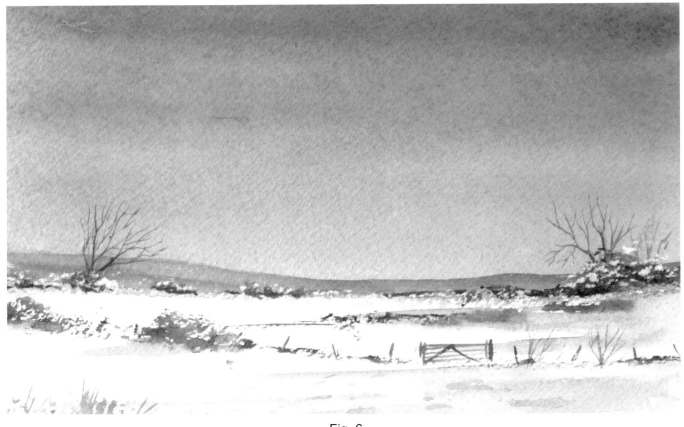

Fig. 6

This sky involves a graduated wash whereby the darkest tones are at the top gradually becoming lighter towards the horizon.

Start by preparing a fluid consistency mix of Cobalt Blue and Light Red to produce a blue/grey colour. Then dampen the sky area with clean water and allow time for the paper to absorb some of the moisture.

Load an extra large wash brush with the mix and using single horizontal brush strokes across the paper, start at the top gradually working down towards the horizon. One large brush load of colour is sufficient to cover the sky, in most cases, at the same time the reducing amount of paint in the brush gradually creates lighter and lighter tones towards the horizon.

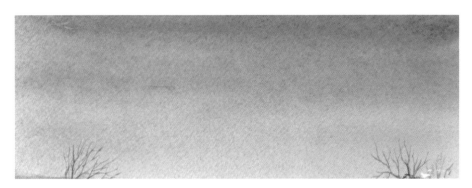

One large wash brush full of paint.

Variegated wash Sky

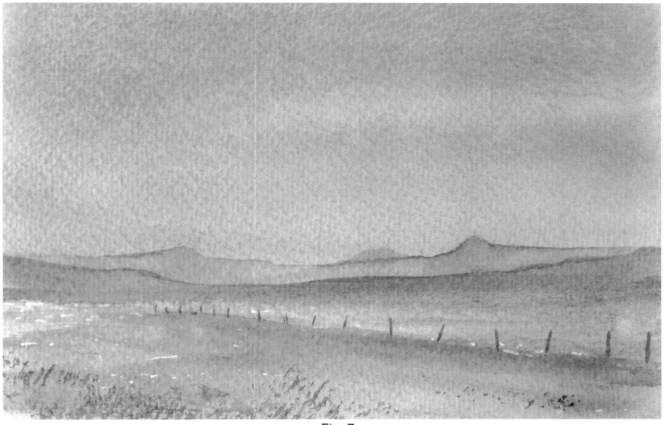

Fig. 7

Y et another method is the use of the variegated wash which entails changing colours part of the way through the sky painting process.

Start by preparing:

 1) Fluid consistency wash of Cobalt Blue.
 2) Fluid consistency wash of weak Light Red.

Dampen the sky area with clean water and allow time for some of the moisture to be absorbed by the paper.

Commence painting at the top of the picture using an extra large wash brush with wash 1) by applying single horizontal brush strokes working down to about the half way point at which stage the colour tone will have become weaker. Rinse the brush in clear water before loading it with wash 2). Then paint the remaining sky area down to the horizon with similar brush strokes.

Note the transition from one colour to another and the lack of any hard demarcation line between the two colours.

Skies Showcase

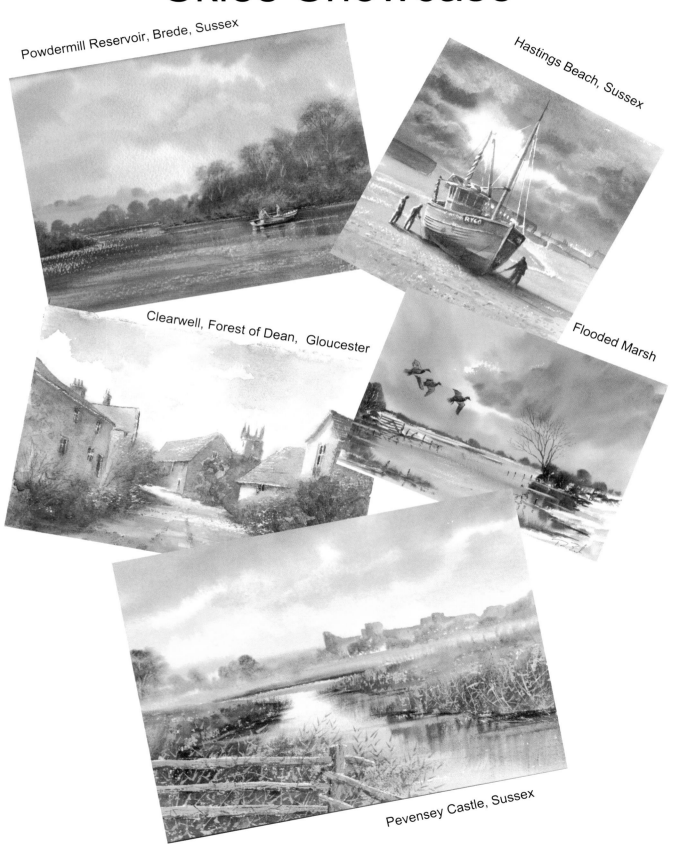

Powdermill Reservoir, Brede, Sussex

Hastings Beach, Sussex

Clearwell, Forest of Dean, Gloucester

Flooded Marsh

Pevensey Castle, Sussex

Skies Showcase

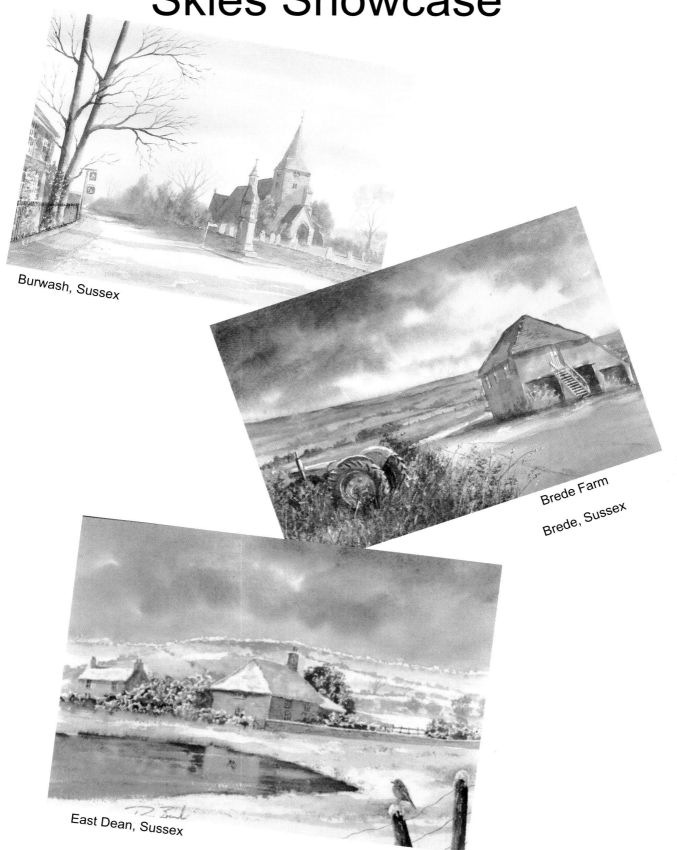

Burwash, Sussex

Brede Farm
Brede, Sussex

East Dean, Sussex

Trees and Foliage

Introduction

It is not unusual for landscape painters to experience difficulty in painting convincing looking trees. The latter play a significant role in most landscape paintings and are, therefore, worthy of observation and study by artists.

The more you pay attention to their shapes, the structure of the branches, the tapering of the trunks and the shapes of different species of tree, the more chance you have of achieving realism in your paintings. Make a point of studying general shapes in winter when trees are without foliage.

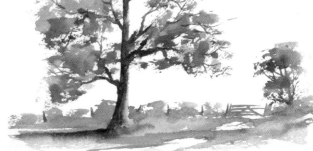

Having gained a knowledge and feel for the general shapes, you will be able to apply broad brush strokes of tone and colour leaving intermediate spaces for the subsequent insertion of trunks and branches thereby creating convincing tree forms.

Obviously the degree of detail you depict will depend upon the locations of the trees in the picture. Those in the immediate foreground will have more detail than the trees in the middle and far distance. The further away they are in the picture the less discernible the detail and the cooler and more muted the colours. Whereas in the middle distance a little more detail is observable and the colours are marginally warmer. Trees in the immediate foreground, ie nearest to the viewer, can display considerable detail and strong colours. Differing levels of detail and tonal values assist in giving depth and recession in a picture. See figures 1 and 2

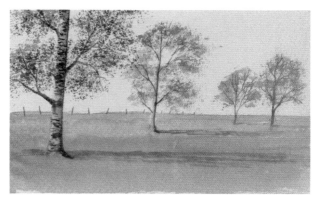
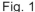

Fig. 1

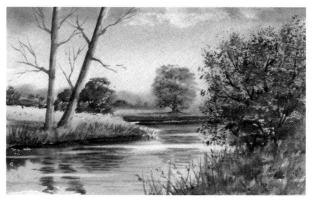

Fig. 2

I have included a number of techniques in this section of the book which, I hope, will assist you to paint realistic looking trees. In the final analysis it is for you to decide how much effort, time and study you will put into practicing painting trees.

Trunks and Branches

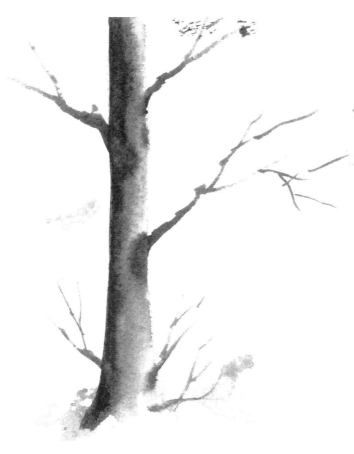

Fig. 3

The trunk and branches shown in Fig. 3 are produced by using 'Technique C' outlined on page 53.

Having drawn the trunk, prepare a medium consistency mix of French Ultramarine Blue and Burnt Sienna to produce a blackish-brown colour.

Use a No. 10 brush to paint a line of the colour about a third of the way across the width of the trunk down the left hand side which for the purposes of this demonstration is the shadow side.

Quickly follow this by brushing clean water down the unpainted area making sure to touch the edge of the still damp applied colour. This effectively teases the colour across the unpainted part of the trunk thereby creating a gradual change in colour tone from dark to light.

I must emphasis that it is essential to work quickly and fluently for this technique to be successful.

While the trunk is still damp use the original colour with a number 2 rigger brush to insert the branches. Paint them in the direction of growth, namely from the trunk outwards.

The best results are obtained if the rigger brush is applied with firm pressure at the start near the trunk gradually reducing the pressure towards the ends of the branches to make thinner marks.

This technique involves painting wet-in-wet albeit in the same colour. The gradation in tonal values across the width of the trunk relies upon quick fluent brushwork. If the original line of colour applied down the shadow side dries before the application of the clean water brushwork then the whole effect being aimed for will not materialise.

It is equally important for the branches to be added while the trunk is still damp in order to produce a cohesive whole object.

It is worth practicing this exercise as fluent brushwork will pay dividends.

Texture in Trees

SILVER BIRCH EFFECT

Texture in tree trunks is largely confined to those trees in the immediate foreground of a picture ie those nearest the viewer. Figure 5 illustrates the result of a technique which provides an effect akin to silver birch trunks.

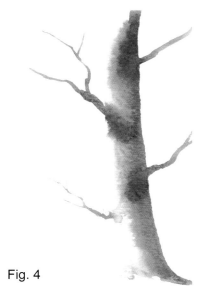

Paint the trunk and branches, using the technique outlined earlier in fig. 3, and allow the paint to dry. See Fig.4.

Prepare a dryish consistency mix of French Ultramarine Blue and Burnt Sienna to give a dark black-brown colour. Then load a No. 8 brush with this colour mix.

Hold the brush as indicated in the following section entitled "The Broad Brush Approach" so that the brush bristles lie flush to the paper and vertically placed in line with the trunk. Apply colour by dragging the side of the bristles here and there across the width of the whole length of the trunk. See Fig. 5. You will note that some areas need to be left untouched by this process.

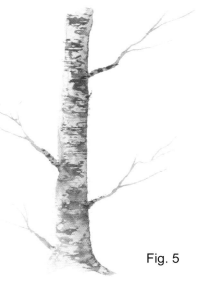

Fig. 4

Fig. 5

VERTICALLY TEXTURED BARK EFFECT

The following technique produces an entirely different texture from the 'silver birch' method described above and is best applied on paper with a rough surface.

It involves separate applications of colour applied wet-in-wet. Each of the second and subsequent applications is applied while the preceding colour is damp. Normally anything in excess of three colours mixed in a palette results in a mud effect, whereas dropping in colour wet-in-wet allowing the paint to mix on the paper enabling multi layers of colour to retain luminosity.

The Method
Start by preparing the following washes:

A) Fluid consistency wash of weak Raw Sienna followed by fluid consistency washes of the following colours:

B) Transparent Yellow.
C) Burnt Sienna.
D) Permanent Rose.
E) French Ultramarine Blue.

Use a No. 10 brush to apply the weak Raw Sienna A) over the whole of the trunk surface and branches. Allow the paint to dry. You may wish to use a smaller brush than a size 10 for the branches.

Make sure that the board is at a slight angle so that subsequent applications of colour will run down the length of the trunk.

Drop in each of the washes B) to E) at the top of the trunk towards the right hand side (the shadow side) using a No. 10 round brush allowing the wash to run down and mix on the paper. Tease each colour across the trunk to provide modellIng and drag each application of colour along the branches and across the ground to provide shadow. I find a damp tissue useful to dab out small highlights here and there on the trunk. Allow the paint to dry.

The next stage requires the preparation of a dryish consistency mix of Burnt Sienna and French Ultramarine Blue to produce a dark brown colour. Make sure that all the previous wash applications are quite dry before using the splayed bristles of a clean dry No. 8 round brush to apply the mix to the trunk with short vertical brush strokes.

To enhance the texture, darken the above mix by adding more of the blue, then use the point of the brush to apply short vertical lines of the colour down the trunk to represent deeper crevices in the bark. Some additional modelling may be required to add highlights in the bark. This can be achieved by using a No. 2 rigger brush with white gouache.

Use a damp tissue to remove small areas of paint from the trunk to give the effect of sawn off branches, then give each such area a dark rim.

Whilst it is not necessary to finish with a glaze, sometimes I prepare a yellowy green fluid consistency mix of Transparent Yellow and Cerulean Blue. Having ascertained that all previous paintwork is quite dry, I apply the prepared glaze over the trunk. In doing so it is essential to ensure that the brush covers each area once only to avoid lifting the existing paint and detail. See Fig. 6 for the final result.

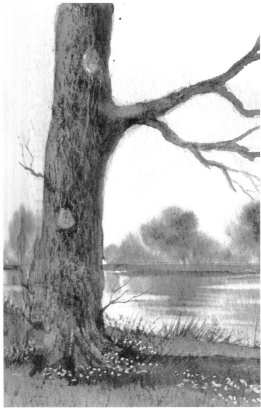

Fig. 6

It is important to ensure that the various washes B to E referred to above are spread over those areas of branches emanating from the main trunk. See Fig. 7.

By spreading each of the washes B to E across the ground immediately adjacent to the tree assists in producing a cohesive whole between the tree and its shadow.

Note that the grasses and flowers are added once the tree and shadow paint is thoroughly dry. See Fig 8.

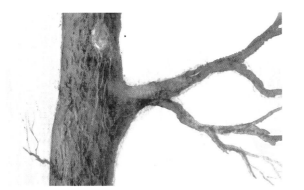

Fig. 7

Fig. 8

The Broad Brush Approach

From time to time I find the following technique useful for the depiction of trees and mid-distant bushes.

Fig. 9

It is advisable to pencil in the general tree shape which may relate to a specific tree type or be more generalised as shown in Fig 9. Note that the tree in the figure is depicted by two arcs each with an associated dot. This format effectively divides the tree into two parts to enable blank or pre-painted areas (e.g. sky colours) to be left into which branches and the trunk growing within the foliage can be added.

The procedure involves inserting the foliage first followed by the parts of the trunk and branches which will be visible through the foliage.

Prepare two medium consistency mixes:

1) French Ultramarine Blue and Transparent Yellow giving a yellow-green colour.

2) French Ultramarine Blue and Transparent Yellow to produce a dark green. The depth of tone depends upon the amount of the blue used.

The bristles of a number 10 round brush should be covered in mix 1). Hold the brush in such a way as to allow the side of the bristles to lie flush on the paper. Start at the uppermost arc and drag the brush towards the dot: repeat this by working round the arc. See Fig. 10.

Fig. 10

Repeat the process with the lower arc taking care to leave blank areas between the two sets of brushwork. While the paint is still damp use the same technique with mix 2) to insert darker accents in the foliage where required. (See Fig. 11).

Fig. 11

You may use Mix 2) with a No. 2 rigger brush for the trunk and branches. Insert the trunk up through the foliage then add the branches in the direction of growth ie from the trunk outwards and upwards.

Highlights can be lifted out of the damp trunk with a piece of tissue if desired. See Fig.12.

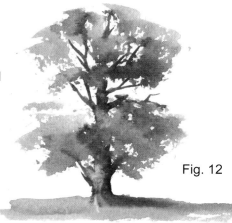

Fig. 12

If carried out correctly this approach can be very effective. Try it for yourself and possibly develop your own version to meet your requirements using your preferred choice of colours.

Sponging Foliage

There are a number of ways available to the watercolourist to depict foliage. A simple, but effective, technique involves the application of paint using a small piece of natural sponge which has a fairly open texture.

Having painted the trunk and branches using the technique described on page 22 (Figs. 4 and 5); prepare a fluid consistency mix of Transparent Yellow and Cobalt Blue to produce a yellow-green colour.

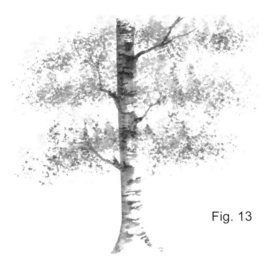

Use a small area of <u>damp</u> natural sponge to soak up the colour mix and apply the paint mainly around the area of the branches using a dabbing motion. Take care not to press too hard with the sponge which should be rotated slightly, whilst off the paper, to avoid regimented foliage patterns.

Add more blue into the remaining mix to produce a dark green, then use the sponge in exactly the same manner, as described above, to add darker accents into the foliage. (See Fig.13).

Fig. 13

Foliage Canopies

Overhead canopies of foliage are fairly simple to paint and can assist the composition of a picture, creating the impression that one is standing immediately under a tree.

The canopy effect is achieved by using a small area of damp sponge as outlined above. Upon completion of the sponging process a No. 2 rigger brush with dark green paint is used to add a few branches here and there as shown in Fig. 14.

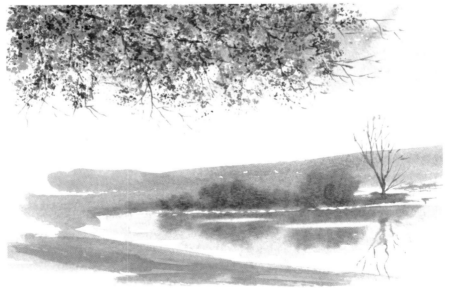

Fig. 14

Trees & Foliage Showcase

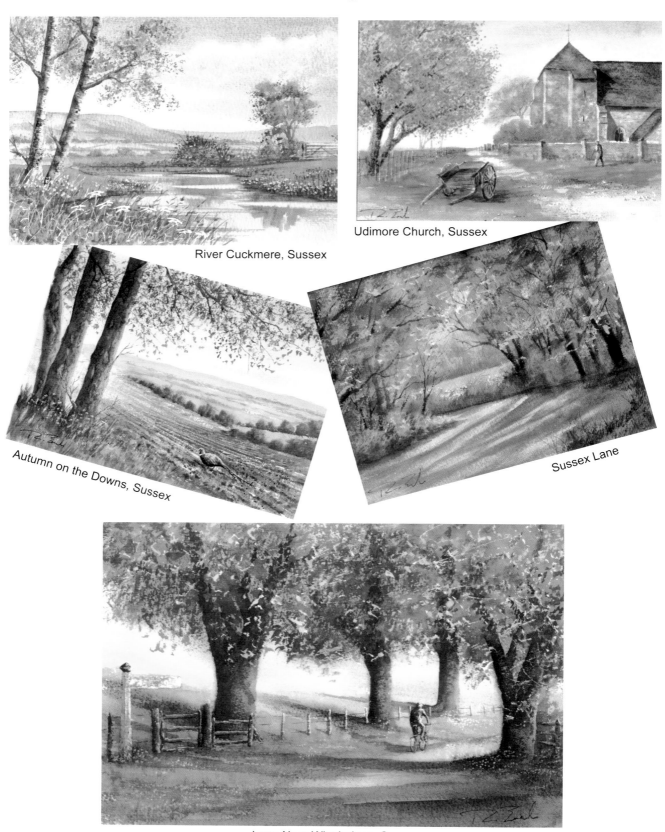

River Cuckmere, Sussex

Udimore Church, Sussex

Autumn on the Downs, Sussex

Sussex Lane

Lane Near Winchelsea, Sussex

Trees and Foliage Showcase

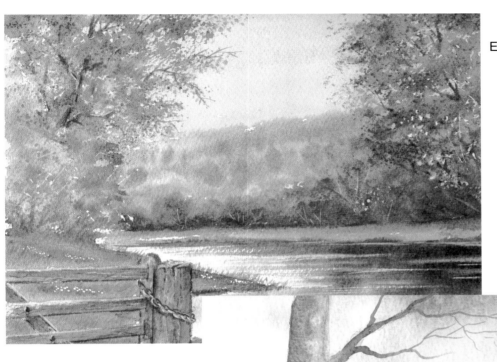

Early Morning

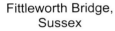

Fittleworth Bridge,
Sussex

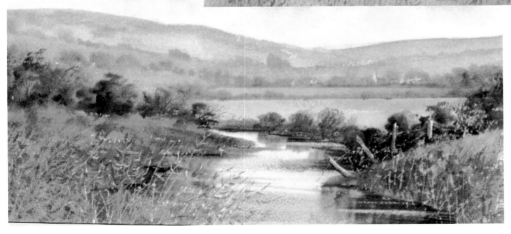

Cuckmere and the Downs
Near Alfriston, Sussex

Water

Introduction

Water is another important ingredient of many pictures, rather like skies it can be used to create moods, reflect colours and distort shapes. It takes many forms from a mirror-like motionless state to gentle movement to turbulent torrents. In its many guises it is an ever present element of much of our landscape. As a consequence it has a certain attraction for most people hence its frequent inclusion in paintings. Its magical attraction is enhanced by the inclusion of reflections which may be hard or soft edged dependent upon the manner of their depiction. Motionless water involves mirror-like reflections which contrast to the blurred imagery produced by moving water.

Water and reflections can be a stumbling block for beginners, consequently at the outset it is wise to avoid complicated 'mirror image' type reflections until you have mastered the painting of reflections so as to give an impression of the surrounding scene. This can be achieved by using broad brush strokes with few colours.

The depiction of water requires planning, preparation and fluent positive brushwork. Without adequate planning and preparation the resultant painting process is liable to error and disappointing results. This will become clear in the remainder of this section of the book in which I will pass on some useful hints, tips and techniques all designed to assist you in achieving successful results.

But first a few words about the need for planning and preparation before a single brush stroke of colour is applied.

PLANNING

It is vital to determine the colours you are going to use for the water and reflections which in essence relay the colours of their surroundings including the sky in many instances. This is the planning part of the overall process.

PREPARATION

All of the required individual colour mixes should ideally be prepared in advance of any colour application to the paper. Very often the success or otherwise of water and associated reflections is dependent upon the mixing of applied colours on the paper, namely painting wet-in-wet.

Finally, practice is an essential ingredient for producing realistic pictures of water and reflections.

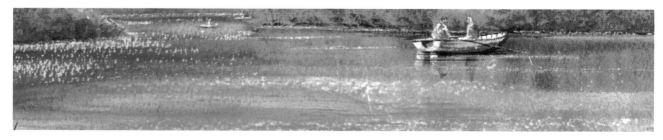

Lake

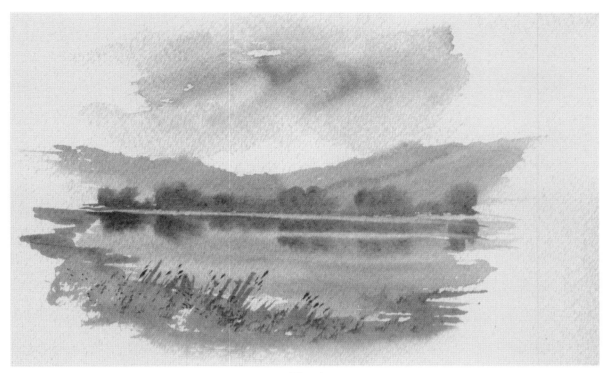

Fig. 1

The watercolour sketch (Fig 1) depicts a fairly simple lake scene with minimal reflections in the water. This first picture involves the use of a very restricted palette and represents an ideal exercise as a starter.

Prepare the following:

1) Fluid consistency mix of Cobalt Blue + Light Red (blue/grey).
2) Fluid consistency mix of Cobalt Blue + Light Red (grey).
3) Dryish consistency mix of Cobalt Blue + Raw Sienna (blue/green).

Use an extra large wash brush to apply mix 1) into the sky area. Before the paint dries, use the same brush with some clean water to touch a few fringes of the colour in order to create some softer edges. Allow the paint to dry.

Use a No. 12 brush with mix 2) to paint the distant landscape making sure to paint to the water's edge. This will enable you to use mix 3) to paint the far bushes over the still wet distant landscape and in so doing achieve soft edges to the tops of the bushes. When wet-in-wet effects are required, it is prudent to prepare all the required colour mixes in advance. In that way the risk of paint drying before the next application of colour is avoided.

Allow the paint to dry thoroughly before painting the water.

WATER AND REFLECTIONS

As the water and reflections are going to be painted wet-in-wet, prepare the following:

A) Fluid consistency mix of Cobalt Blue and Light Red to produce a blue/grey to reflect the sky colour.

B) Dryish consistency mix of Cobalt Blue and Raw Sienna resulting in a blue/green colour to reflect the bushes.

C) Fluid consistency mix of French Ultramarine Blue and Transparent Yellow (yellow/green).

Use a No. 14 brush to paint mix A) over the whole of the water area making sure that the tonal colour of the water in the foreground is that much darker than in the rest of the area. While the paint is still damp use vertical brush strokes with mix B) to paint the reflections of the bushes. Before the paint dries use a damp ¾ inch flat brush to lift out one or two flecks of the water colour as indicated in Fig. 2 below. Allow the paint to dry.

Fig. 2

Having used a No. 14 brush with mix C to paint the foreground grass, apply the same mix with a No. 2 rigger brush to insert the taller foreground grasses and reeds. Finish by using Permanent Rose to add a few dots of colour within the reeds.

This simple watercolour sketch embraces a number of important elements for all of us. In spite of its simplicity its execution requires planning, careful timing for the wet-in-wet processes, attention to the mixing off the colours with particular reference to their consistencies. It represents a worthwhile exercise for us to try before going on to other things.

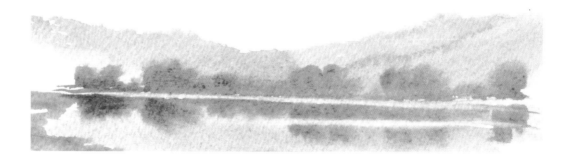

When painting reflections try to reproduce the same shapes and heights of the objects being reflected.

Still Water Lake

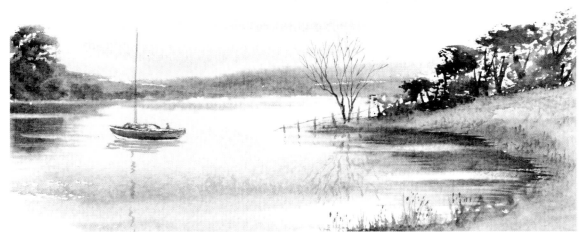

Fig. 3

In this watercolour sketch depicting a still water lake in late evening the water will be the last part of the picture to be completed.

Start by preparing the following:

 1) Fluid consistency mix of Cobalt Blue + Light Red to give a grey/blue.
 2) Fluid consistency mix of Naples Yellow + Permanent Rose to produce a reddish/orange colour.
 3) Dryish consistency mix of Cobalt Blue + Light Red to give a bluish colour.
 4) Medium consistency mix of Raw Sienna + Burnt Sienna + Cobalt Blue to give a green/brown.
 5) Medium consistency mix of Permanent Rose + Cobalt Blue + Light Red to give reddish/brown colour.

Paint the sky using mix 1) followed by mix 2), both colours being applied directly onto dry paper with an extra large wash brush allowing the colours to intermix on the paper. While the sky is still damp use a No. 12 brush with mix 3) to paint the distant landscape.

When the paper is almost dry use a No. 12 brush with mix 4) to paint the mid-distant landscape. See Fig. 3a. Dry off the painting.

Fig. 3a

Fig. 3b

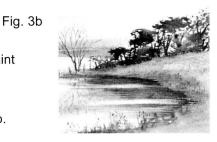

With the side of the bristles of a No. 10 brush use mix 5) to paint the bushes, grass and trees on both sides of the picture. See Figs. 3a and 3b.

Finally use a No. 2 rigger brush to paint the bare tree in fig. 3b.

WATER AND REFLECTIONS

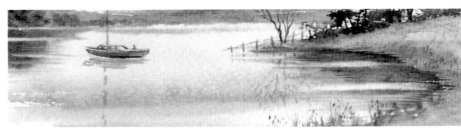

Fig. 4

Start by preparing:

 A) Fluid consistency mix of Naples Yellow + Permanent Rose (reddish orange).
 B) Fluid consistency mix of Cobalt Blue + Light Red (blue /grey).
 C) Dryish consistency mix of Raw Sienna + Burnt Sienna + Cobalt Blue (green/brown).
 D) Medium consistency mix of Permanent Rose + Cobalt Blue + Light Red (reddish brown).
 E) Fluid consistency mix of Cobalt Blue + Light Red (blue/grey).

Dampen the water area of the paper and allow time for the paper to absorb some of the moisture. With a No. 14 brush use horizontal strokes to apply mix A) to the area of water towards the far bank. This must be followed quickly by applying mix B) into the foreground water. While the paint is still damp use <u>vertical</u> brush strokes to apply mix C) to represent reflections of the bushes and bank.

Finally use a damp ¾ inch flat brush to lift out horizontal strips of the paint. This aids the effect of wateriness.

Finishing off

When the painting is dry use a No. 10 brush to apply Mix D) to the boat hull and mix E) to insert the mast and cabin structure. This latter mix is then applied with horizontal brush strokes to add the boat and mast reflections.

Finally use a No. 2 rigger brush with the same mix to add the reflection of the bare tree. See Fig. 5

NB. The boat, mast and tree reflections are broken lines.

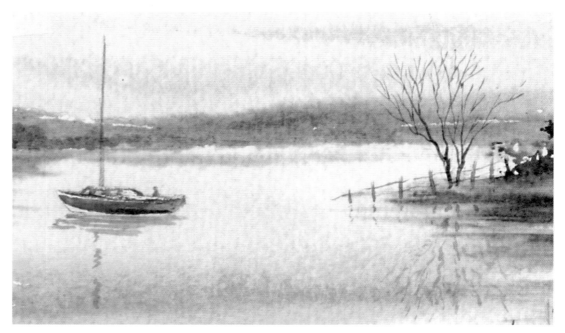

Fig. 5

Having practiced this type of picture a few times you may care to experiment with your own colour schemes and techniques.

Waterfall and River

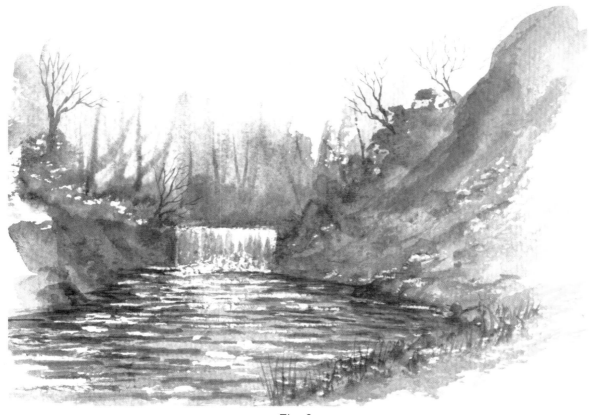

Fig. 6

The watercolour sketch in Fig. 6 adds another dimension, so to speak, to our experience of painting water. In this case we are faced with both falling water and moving or disturbed water. If you compare this picture with those of the two lakes illustrated earlier you will notice a significant change in the reflective qualities of the still and moving waters. In the latter the reflections are completely broken up by the current and surface movement created by the waterfall.

The manner in which we may deal with this change is illustrated in the techniques outlined below.

Start by creating a simple pencil sketch and then apply masking fluid with a ruling pen to parts of the waterfall and to the area immediately beneath it.

Also apply masking fluid in small white horizontal flecks in random areas of the flowing river. See Fig. 7 in which the masking fluid is depicted in white.

The areas covered by the masking fluid will be preserved as white paper.

In applying the masking fluid you are essentially painting the effects of the turbulence in the water arising from the waterfall.

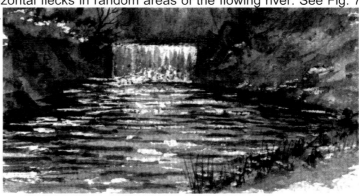

Fig. 7

While the masking fluid is drying, prepare:

 1) Fluid consistency mix of Cobalt Blue + Light Red (light blue/grey).
 2) Medium consistency mix of Cobalt Blue + Raw Sienna (green).
 3) Medium consistency wash of Permanent Rose (crimson/red).
 4) Fluid consistency mix of Burnt Sienna + Cobalt Blue (brown/grey).

Make sure that the masking fluid is dry before using a No. 10 brush with mix 1) to paint some far distant trees. Use the same mix to paint in a few trunks. When the paint is almost dry, use mix 2) to add some bushes either side of the river followed by small touches of mix 3). Rinse the brush with water then lightly blend the bottom edge of the bushes into the bank. Finish this stage by using a No. 2 rigger brush with mix 1) to add a few trunks and branches.

Use mix 4) to paint the two banks with touches of mixes 1) and 2) placed in just before the banks are dry, also drop in touches of mix 3). Allow the paint to dry. See Fig. 8

Fig. 8

Water and Reflections

We have seen the need for preparation in advance of painting in the earlier stage of this picture, this aspect assumes even greater importance now that we are faced with painting the water and reflections. Before we do anything else we need to prepare the colour mixes we intend to use.

 A) Fluid consistency mix of Cobalt Blue + Light Red (light blue/grey).
 B) Medium consistency mix of Burnt Sienna + Light Red (brown/grey).
 C) Medium consistency mix of Cobalt Blue + Raw Sienna (green).
 D) Medium consistency mix of Cobalt Blue + Light Red (light blue/grey).
 E) Medium consistency mix of Cobalt Blue + Raw Sienna (green).

Using a No. 12 brush apply mix A) to the waterfall and the area of the river. When almost dry add small horizontal brush marks of various colour combinations of mixes B), C) and D) to create ripples of colour. Allow this to dry thoroughly then remove the masking fluid by rubbing it off lightly with your fingers. This will leave flecks of white paper which will enhance the sense of movement and froth on the water.

You may wish to use touches of mix A) into some of the white areas to give the impression of shadow.

Finish the picture by using mix E) with a No. 2 rigger brush to insert the grasses in the foreground.

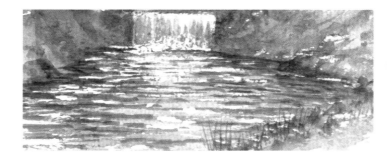

Fig. 8a

The finished broken reflections add a sense of movement to the water. See Fig. 8a

Incoming Tide

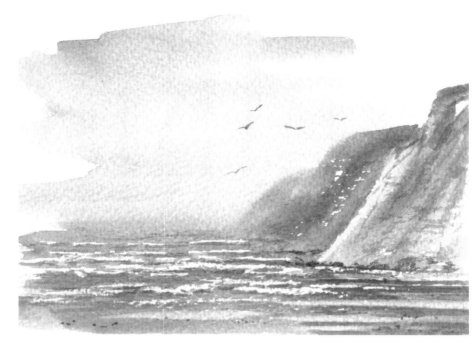

Fig. 9

The watercolour sketch (Fig. 9) illustrates another aspect of moving water. Simple coastal scenes can be quite appealing but need careful planning.

After drawing the picture, use the ruling pen to apply masking fluid in short ragged horizontal marks to preserve the white paper which represents the crests of the waves. This picture is no different from the earlier examples in so far as there is a need for a number of mixes to be prepared in advance of any application of colour.

Start by preparing:

A) Fluid consistency mix of Cobalt Blue + Raw Sienna (blue/green).
B) Fluid consistency mix of Raw Sienna + Burnt Sienna (yellow/brown).

1) Fluid consistency mix of Cobalt Blue + Light Red (blue/grey).
2) Dryish consistency mix of Cobalt Blue + Raw Sienna (blue/green).
3) Medium consistency mix of Raw Sienna + Burnt Sienna (yellow/brown).

Use a No. 12 brush with mix 1) to apply horizontal broad brush strokes to cover the sky area down to the horizon including the distant cliffs. While the paper is still damp apply mix A) to the sea area from the horizon to the water's edge where you should finish off by applying mix B) to represent the sand.

Just before the paper dries use a No. 12 brush to paint the cliffs starting with mix 2) (wet-in-wet) for the furthest cliff and finishing on dry paper with mix 3) for the nearest cliffs.

Thoroughly dry the picture before removing the masking fluid.

Finally use a No. 10 brush with mix 1) to add a few shadows under the white crests of the waves and also in the crevices of the nearer cliff, The same mix could be used to dot in some pebbles on the sand. A sense of wateriness can be achieved by using a damp ¾ inch flat brush to lift out one or two horizontal flecks from the sand.

Marsh, Dyke and Church

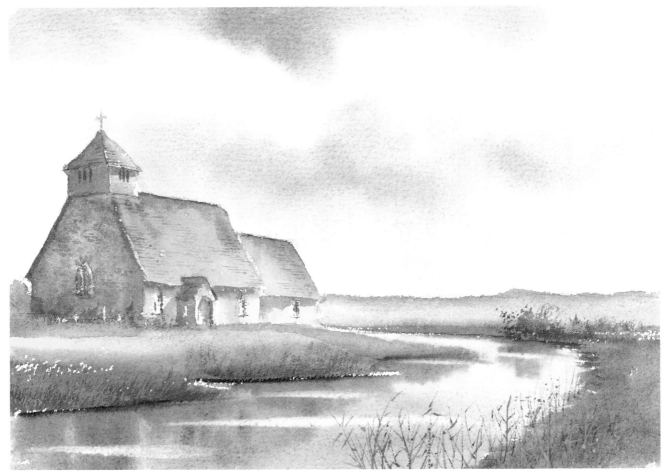

Fig. 10

My watercolour sketch (Fig. 10) is of a delightful little church to be found on Romney Marsh in Kent.

Start by preparing:
 A) Fluid consistency mix of Cobalt blue + French Ultramarine Blue (bluish).
 B) Fluid consistency mix of weak Naples Yellow + Permanent Rose (weak orange).
 C) Medium consistency mix of French Ultramarine Blue + Light Red (grey).

Dampen the sky area with clean water and allow time for the paper to absorb some of the moisture. Then using an extra large wash brush apply mix B) to the lower portion of the sky area followed by mix A) at random in the remaining area of sky taking care to leave unpainted areas. Finally apply mix C) to insert the darker clouds. Allow the paint to dry.

Prepare:
 D) Medium consistency mix of Cobalt Blue + a touch of Permanent Rose (bluish).
 E) Medium consistency mix of Cobalt Blue + Raw Sienna (green).
 F) Dryish consistency mix of Cobalt Blue + Raw Sienna + Burnt Sienna.(brown/green).

With a No. 12 brush use mix D) to depict the distant landscape followed by mix E) applied wet-in-wet immediately below the distant landscape and across ground in front of the church to depict the grass. Apply mix F) wet-in-wet to delineate the darker bank areas of the dyke. Allow the paint to dry before applying mix F) to depict the small bushy grasses on the far bank of the dyke. Do not insert the grasses on the right hand near bank at this stage.

The church roof and walls require the preparation of 3 washes, namely:

G) Fluid consistency wash of weak Cobalt Blue (lightish blue).
H) Fluid consistency wash of Burnt Sienna (orange/brown).
J) Fluid consistency wash of Light Red (red/brown).

Using a No. 10 brush paint the roof with wash H) and use wash J) for the walls. While the walls are still damp drop in some wash G) into the shadow sides of the roof and walls allowing the colours to intermix on the paper. Allow the paint to dry.
Use mix N) , see below, to depict the windows, doors and the eave shadows.

The Dyke

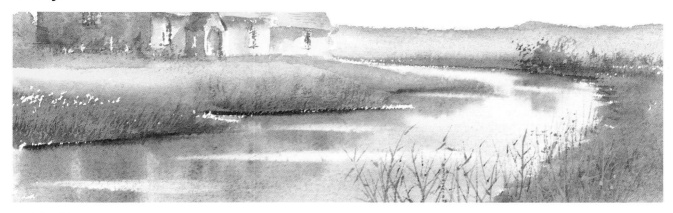

Fig. 11

WATER AND REFLECTIONS

As the whole of the dyke area will be painted wet-in-wet it is essential to prepare the following mixes and washes prior to any attempt to dampen the paper:

K) Fluid consistency wash of Cobalt Blue (light blue).
L) Dryish consistency mix of Cobalt Blue + Raw Sienna (dark green).
M) Dryish consistency wash of Burnt Sienna.
N) Dryish consistency wash of Cobalt Blue + Light Red (grey).

Dampen the entire area of the dyke with clean water and give the paper time to absorb some of the moisture before applying wash K) with a No. 12 brush. Whilst the paint is still damp use vertical brush strokes to apply mix L) under the dyke bank followed by wash M) alternating with mix N). In doing so ensure that the colours and tones in the water correspond with the surroundings above.

Before the paint dries use a damp ¾ inch flat brush to lift out horizontal flecks of paint. See Fig 11a.

Finally make sure that the paint is absolutely dry prior to applying mix L) with a No. 2 rigger brush to paint the reeds on the nearside bank of the dyke.

In reality the reflections in the dyke were a mirror image of the church and immediate surrounds. The prospect of painting a mirror image can be quite daunting for the beginner. In this example I have just dropped in some of the local colours of the church and sky to give an impression of reflections in the water. This is sufficient to indicate that it is water rather than a road or track. (Fig. 11).

NB. The painting of reflections requires practice. Try it for yourself remembering to work as <u>quickly as possible</u>. Reflections in this picture involve painting wet-in-wet therefore requiring all colours to be prepared in advance.

Fig. 11a

Water Showcase

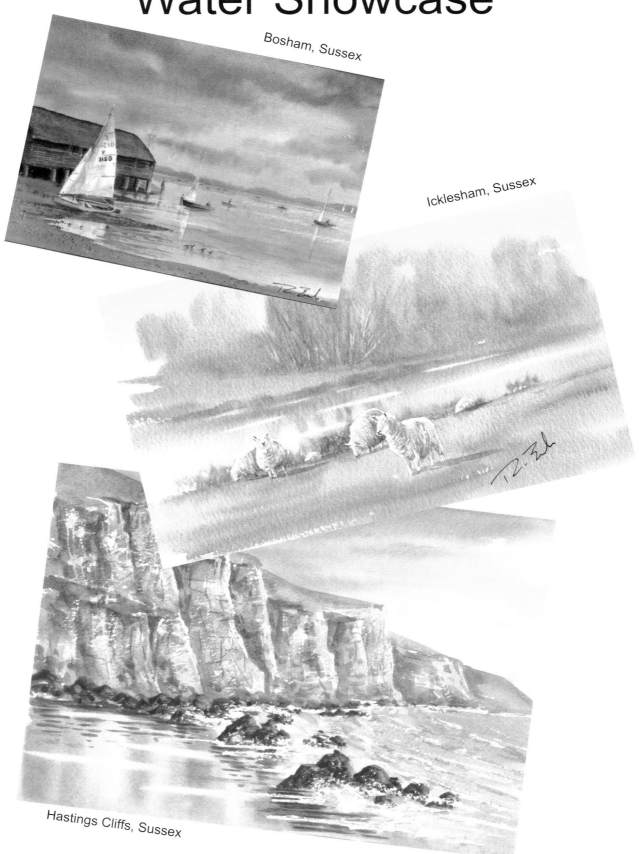

Bosham, Sussex

Icklesham, Sussex

Hastings Cliffs, Sussex

Water Showcase

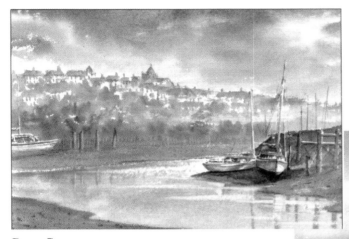

Rye, Sussex

Late Evening

Pevensey Castle, Sussex

Chichester Canal, Sussex

Shadows

Introduction

In our two dimensional paintings we are depicting the three dimensional world in which we live. If we were to paint our pictures without shadows they would appear almost plan-like with a consequent loss of both reality and impact. (Fig. 1).

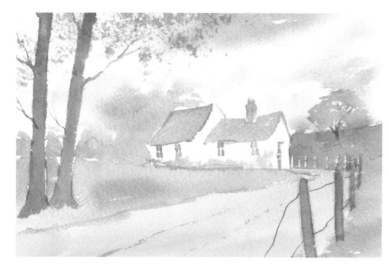

Fig. 1

This painting illustrates just how dull and uninteresting a normal scene can become when we ignore the importance and impact of light.

Fig. 2

By inserting shadows we can transform our plan-like painting into something quite different. (Fig. 2).

Our new picture has become a recognisable entity which equates with our three dimensional surroundings.

The inclusion of the shadows adds impact which is singularly lacking in the flat plan-like version (Fig. 1).

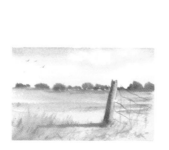

This section of the book outlines some basic aspects of the nature of shadows in addition to explanations of techniques for their depiction.

The Nature of Shadows

It is essential to understand the nature, characteristics and types of shadows in order to be able to interpret them in our watercolour paintings. Much of this may be regarded as being self evident, however, many of us tend, perhaps, to *look* at things around us without really *seeing* and understanding them. As artists we require to have an awareness of the objects of our attention regardless of the manner of our personal interpretation of them in our paintings.

Cast Shadows

Diffused shadows

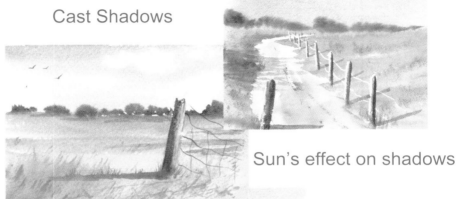

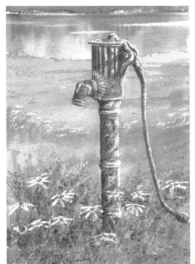

Sun's effect on shadows

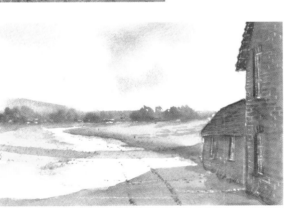

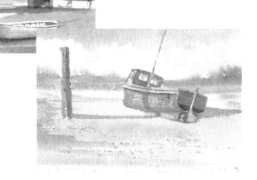

Shadows and Contours

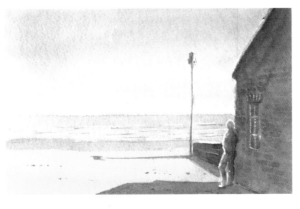

Area in Shadow

Hard edged Shadows

The Nature of Shadows

In simplistic terms shadows may be regarded as being broadly of two types, namely:

1) *cast shadows* - are the shadows cast directly by an object thus taking on the object's shape in some measure. Such shadows fall on adjacent areas and they assume the surface contours of those areas.

2) *areas of shadow* (ie areas in shadow) these are areas which are not in direct sunlight or general brightness. They do not include those areas covered by cast shadows.

In Fig. 1 the sunlight is coming from the left hand side hence the strong cast shadow thrown by the post.

Note how the cast shadow assumes the contours of the boat hull. The assumption of adjacent contours is an important point to bear in mind when faced with the depiction of cast shadows.

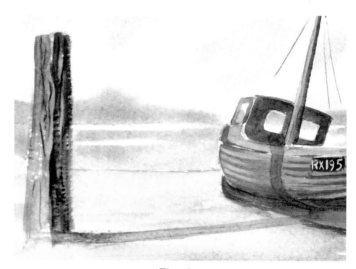

Fig. 1

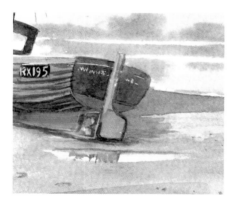

Fig. 1a

In Fig. 1a note that the stern of the boat Is in an area of shadow.

Note the cast shadow thrown by the boat on the right hand side. It is possible to deduce from the cast shadow that the adjacent ground is relatively level.

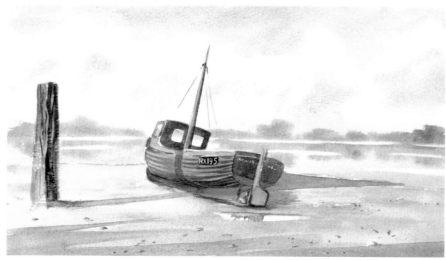

The Nature of Shadows
continued

Strong sunlight generally creates sharp hard edged shadows. Fig. 2 illustrates the effect of such sunlight.

As a matter of interest the walls of the building are in an area of shadow.

Fig. 2

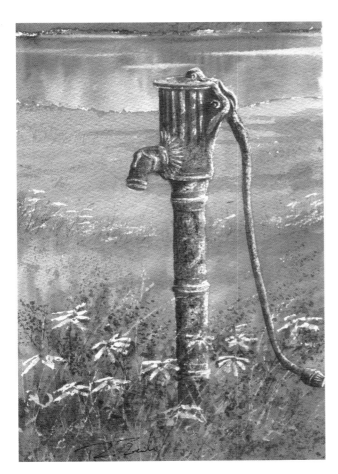

In contrast, diffused lighting gives rise to subtle soft edged shadows.

The painting of the Ancient Pump (Fig. 2a) exhibits such softness.

In spite of their delicacy such shadows play a vital role in depicting contour. They are unobtrusive and yet positive in their impact.

Fig. 2 a

The Nature of Shadows

continued

It should be borne in mind that shadows are not static, their size and position are dictated by the sun's movements, consequently when painting outdoors it is wise at the outset to make sketch notes of shadow positions prior to painting as their locations will almost certainly change during the painting process.

At any one time shadows will always fall in the same direction as their position is dependent upon the height and position of the sun in the sky. In Fig. 3 the sun would be low towards the left hand side of the picture.

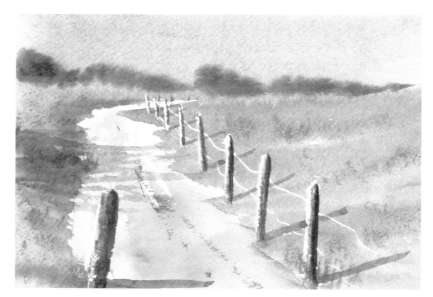

Fig. 3

Fig. 4 depicts the fence later in the day when the sun's position has changed from that in Fig. 3 above. Note that although the shadow position has changed all shadows are cast in the same direction.

Fig. 4

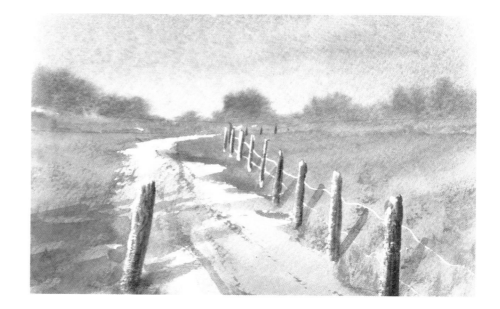

The Nature of Shadows
Continued

When painting from photographs containing no clear evidence of the direction of the light source, it is necessary to decide the light direction prior to painting. It is probably wise to assume the source of light as coming from either the right or left of the picture as this will assist in injecting most drama into the finished painting.

When making such a choice care should be taken to assume that the larger areas of principal objects are in sunlight. The reason being to provide significant light areas in the overall picture thereby enhancing the impact.

Fig. 5

The painting in Fig. 5 is based upon a photograph taken on a sunny day, the light was coming from the right hand side. Note that the larger areas of the boat and the two buildings are sunlit hence providing significant light areas in the overall picture.

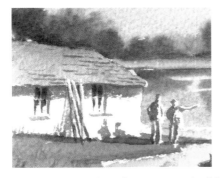

Fig. 5a

Note the cast shadows created by the two figures and the poles leaning against the building in Fig. 5a. In particular note the way in which the cast shadows from the figures fall horizontally along the ground and vertically up the adjacent wall.

The application of masking fluid, prior to the painting stage, to the sunlit sides of the figures serves to enhance the contrast between the highlights and the area of shadow on the figures.

It will be noted in Fig. 5b that the near end of the boathouse is in an area of shadow. The building itself is throwing a cast shadow towards the left and that the cast shadow by its shape indicates relatively level ground contours in the immediate vicinity of the boathouse.

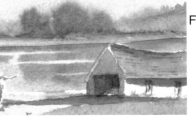

Fig. 5b

Attention is drawn to the cast shadow arising from the eaves overhang on the sunlit side of the building. This shadow plays an important role in the modelling of the sunlit facade of the boathouse.

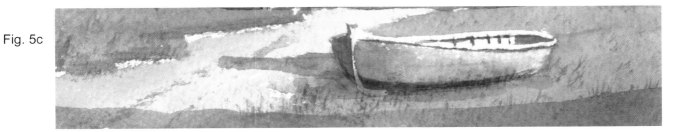

Fig. 5c

In Fig. 5c there are two types of shadow, namely, the cast shadow produced by the boat which indicates that the adjacent ground contour is relatively flat. The far side of the boat prow is in an area of shadow.

The Nature of Shadows
Continued

Shadows are longer when the sun is low in the sky, principally early morning, late evening and during the winter months. Conversely shadows are shortest when the sun is high in the sky.

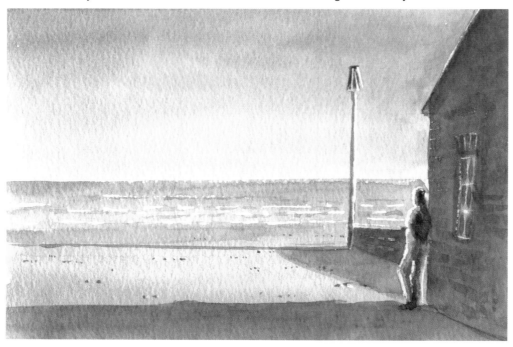

Fig. 6

The long shadows in Fig. 6 indicate that the sun is low in the sky. Whereas the much shorter shadows in Fig. 6a below provide evidence of the sun being much higher. The hard edged shadows in both pictures are indicative of strong sunlight.

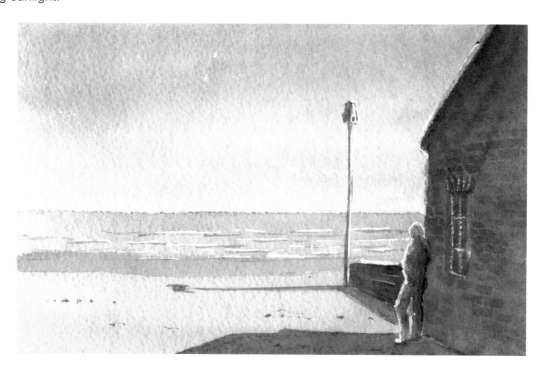

Fig. 6a

The Nature of Shadows

continued

Often there are subtle shadings of colour depth within a single shadow. It is common for shadows to contain hints of reflected colours, they are never pitch black. See the cast shadow from the post in Fig. 7. The depth of tone is darker nearer the post gradually becoming lighter towards the shadow's end.

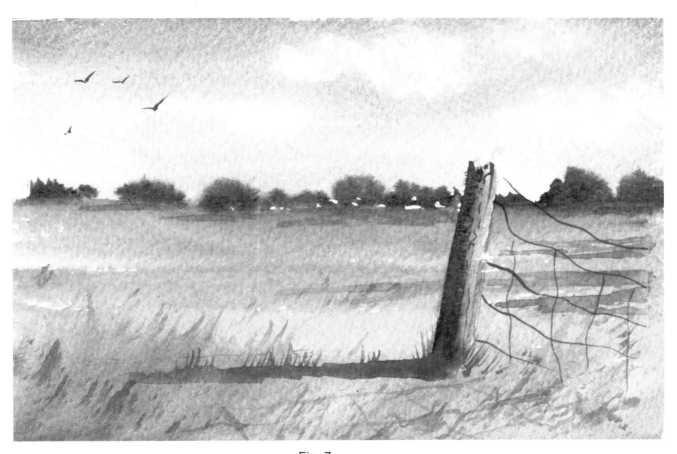

Fig. 7

There are two further aspects of shadows which artists should bear in mind, namely:

1) In tonal terms, nearer shadows are darker than those further away. The depth of tone weakens progressively the greater the distance away.

2) Shadows become progressively foreshortened the further away they are.

Shadows - Watercolour Techniques

It is now obvious that artists need to treat shadows with respect and to use their many attributes to advantage in their paintings. This is an opportune moment to consider some of the practical issues with which we are faced in order to capitalise on the scope shadows provide. The techniques outlined in this part of the book provide a sound springboard for the realistic depiction of shadows in watercolour paintings.

Whilst the techniques are proven means by which shadows may be introduced into paintings, they do not constitute hard and fast rules. Quite the contrary, it will become self evident that there is considerable latitude for personal experimentation in the context of the techniques cited.

Technique A - Glazing

In my opinion glazing is one of the most successful means of depicting shadows in watercolour.

Glazing involves the application of a layer, or layers, of suitable colour over an existing colour to provide the desired depth of tone and colour for both a cast shadow and an area of shadow. Note that the existing colour to be glazed over must be absolutely dry prior to applying the glaze colour.

Particular care is needed to ensure that the glaze is applied quickly and confidently touching any area *once* only. Failure to do so could result in the existing colour being lifted or disturbed.

The glazing process may need to be repeated several times over the same area to achieve the desired result, but remember to allow the paint to dry before each repetition.

The application of a glaze over an original colour can produce a variety of shadow colours and tones dependent upon the colour used. Fig. 1 illustrates several possibilities using different blues.

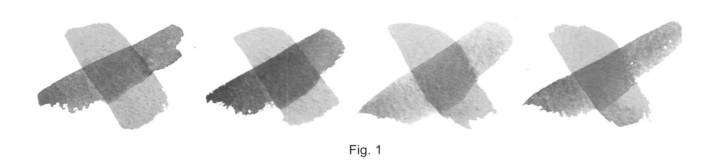

Fig. 1

| Cobalt Blue over Light Red | French Ultramarine Blue over Light Red | Cerulean Blue over Light Red | Paynes Grey over Light Red |

Glazing need not be confined to using a single colour as it is possible to use mixtures of colours, some example mixtures are listed below:

- French Ultramarine Blue + Light Red
- Indian Red + Cobalt Blue
- Indian Red + French Ultramarine Blue
- Light Red + Cerulean Blue

I recommend that you should experiment and discover glazes for yourself thereby widening your scope in the depiction of shadows. It is wise to use some blue as shadows normally contain an element of blue by virtue of their cool nature.

Examples of the application of this technique are shown on the next page.

Technique A - Glazing
continued

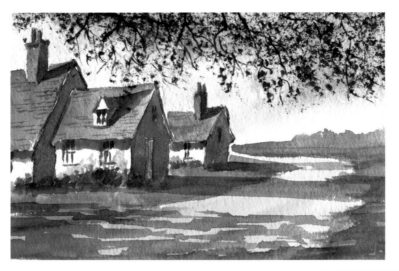

All the areas of shadow and the cast shadows in this painting are glazes consisting of mixes of Cobalt Blue and Indian Red

The area of shadow of the chimney and the shadow the latter casts upon the roof have been achieved by using a Cobalt Blue glaze. In this instance a single application of glaze was insufficient to produce the required depth of shadow. Two successive glazes were applied over the original colour.

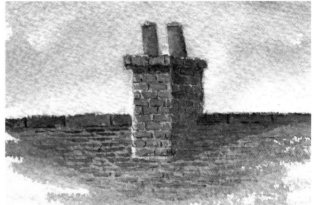

The absolute highlights in the clothing were achieved by covering the areas with masking fluid prior to painting.

After applying the dark clothing colours to the shadow side of the figure the masking fluid is removed. The light gradations in the clothing were made using a brush with clean water to soften the edges of the dark areas.

Finally a glaze of Cobalt Blue was used over the grass to add the fisherman's cast shadow.

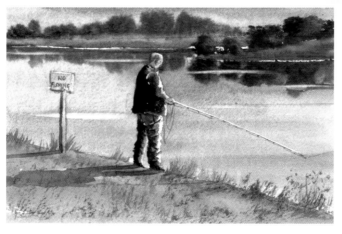

NB If you are uncertain as to the strength of colour glaze to be used, it is advisable to err on the paler side. Remember that once a glaze is applied over an existing colour it cannot be removed without removing the under-colour. Successive pale glazes can be applied until the desired depth of colour and tone are attained.

NB. When passages of paintings are completed and are absolutely dry, then and then only should colour glazes be applied.

Technique B - using Neutral Tint Colour

This technique for depicting shadows relies upon the use of neutral tint colour. It involves mixing neutral tint with the original colour. The resultant darker version of the original colour can be used to depict the required shadow.

The depth of tone of the shadows produced by this technique is dependent upon the amount of neutral tint used in the mix.

In the illustration below I have deliberately used three different colours for the buildings. In each case the resultant mix of the original colour and neutral tint has been used to paint the areas of shadow on the right hand walls, the cast shadows under the eaves and left hand sides of the buildings.

1 Raw Sienna	1a Raw Sienna + Neutral Tint
2 Light Red	2a Light Red + Neutral Tint
3 Burnt Umber	3a Burnt Umber + Neutral Tint

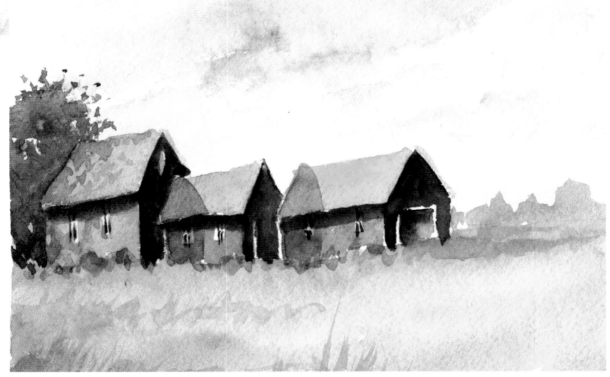

Neutral tint is a very versatile colour worthy of consideration in the context of shadows: experimentation in its use is recommended.

Technique C - using the Object's own Colour

There are instances when areas of shadow may be depicted by using the object's own colour. This technique is particularly suited to rounded, cylindrical and curved shapes where tonal gradation is required, eg. on boats, posts, masts, tree trunks, oasts etc.

The object's colour must be made relatively dark in tone as this technique relies upon the colour being diluted gradually to progress from dark to light shades.

The technique involves using a fluid consistency dark mix of the colour being applied to the shadow side of the object approximately one third of the way across the object's width, for example across the oast roof, the tree trunk and the post in the illustration below. Followed immediately by brushing with clean water in the remaining two thirds of the unpainted area ensuring that this brushwork just touches the edge of the applied colour: in doing so some of the colour is teased across the unpainted area thereby creating a gradual change in tone from dark to light producing the rounded appearance.

The picture below illustrates the results of this technique. In particular note the effects on the tree trunk, oast and post.

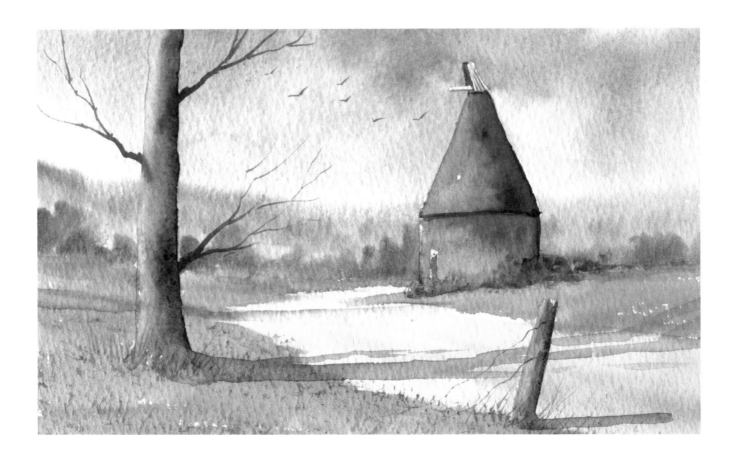

Technique C - using the Object's own Colour

Try this technique for yourself. Start by drawing a simple tree trunk or post, then prepare a dark fluid consistency mix of French Ultramarine Blue + Burnt Sienna to make a blackish/brown colour. Then follow the instructions outlined below.

Stage 1

Pencil drawing

Stage 2

Apply first brush stroke of the colour mix (ie French Ultramarine Blue + Burnt Sienna) down the right hand (shadow) side of the trunk. This band of colour should span about a third of the width of the trunk.

Stage 3

Quickly brush the unpainted area with clean water at the same time ensuring that the brush touches the painted edge.

The finished stage should result in a gradation of tones from dark to light. The effect gives modelling to the trunk.

Whilst the paper is still damp you may add some branches working from the trunk outwards in the direction of growth.

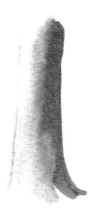

Technique D - dark undertones in foliage

This technique provides a means of introducing shadows into foliage.

It is reliant upon the very first step being the application of a wash of the desired shadow colour into dampened paper in the area(s) of the foliage where shadow is required.

The shadow colour must be allowed to dry before normal foliage painting commences over the top of the shadow wash.

This technique results in the darker tone of the initial shadow wash showing through the finished foliage giving the effect of darker accents.

In the example below the initial shadow wash involved a medium consistency mix of French Ultramarine Blue + Indian Red being applied to dampened paper.

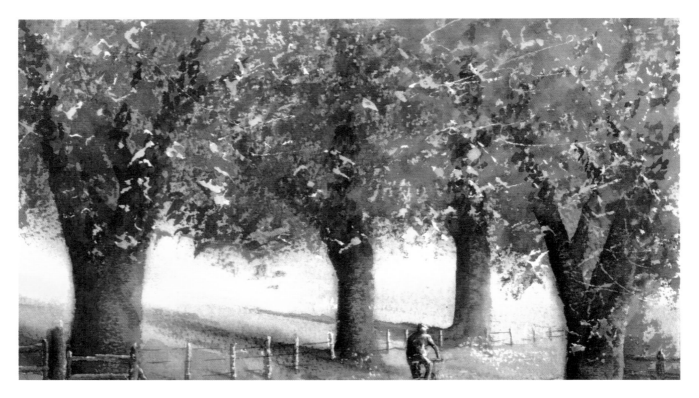

The following suggested medium consistency mixes are suitable for Technique D:

French Ultramarine Blue + Light red French Ultramarine Blue + Burnt Sienna

Cobalt Blue + Indian Red Cobalt Blue + Light Red Cobalt Blue + Burnt Sienna

I recommend that you try your own mixes for this technique which provides much scope for experimentation.

Technique E - Stippling

Stippling is yet another means of introducing and creating darker accents within foliage. Using the tip of the brush in conjunction with say, Cobalt Blue or French Ultramarine Blue, stipple (i.e. Dot or dab) the colour into the already painted foliage area. It is important to ensure that the original paint is dry prior to stippling.

A greater degree of control and precision is possible if the colour mix being used is not too fluid. In fact it is preferable to use a medium consistency mix.

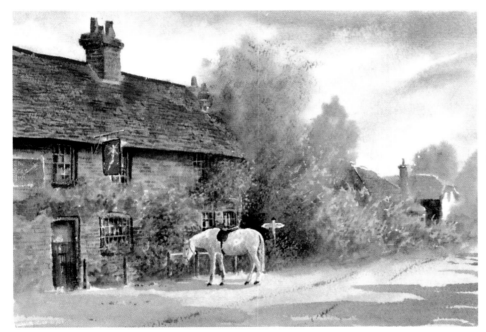

In this Painting stippling has been used to add the darker shadow accents in both the ivy and the bushes.

Stippling was applied to provide shadow detail in the hedgerow in this painting.

Technique F - Wet in Wet

This technique involves the application of shadow colours or mixes on top of existing colour before the latter dries out, ie the paper is still damp when the shadow colour is applied.

This wet in wet approach produces subtle soft edged shadows which merge into the adjacent areas of the painting.

Some soft edged shadows are vital when painting skies and are of equal significance where shadows in foliage are required. Examples of these two aspects of painting are shown below.

In this picture the sky area was dampened prior to painting. The sky was then painted and the darker cloud accents were added whilst the original sky colour was still damp.

The picture is evidence of the subtle soft edged shadows obtainable by using the wet in wet technique.

The same soft edged shadow effect can be achieved when painting foliage.

Having applied the chosen green colour mix to depict the foliage, the darker shadow colour can be obtained by adding more blue to the original colour mix.

The darker mix should then be dropped into the still damp foliage area to create the darker accents in the desired shadow side.

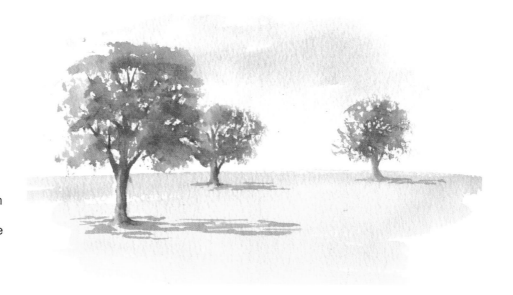

NB It is wise to plan the colours to be used and to consider preparing all of them prior to painting. By doing so it prevents the possibility of the original paint drying out before you are ready to apply the shadow colour.

Sundry Techniques

When painting cast shadows it is advisable to paint from the subject outwards thereby ensuring that the darkest and lightest shades of the shadow are respectively nearest and furthest away from the subject. The figure below illustrates this point and at the same time shows that within a single shadow it is possible to have varying depths of tone.

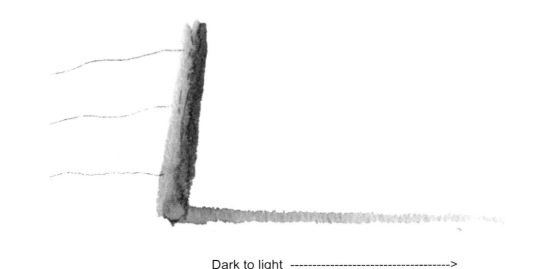

Dark to light ------------------------------------->

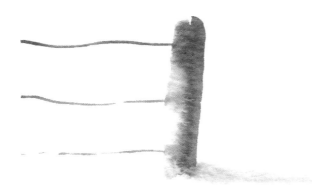

Painting diffused cast shadows

One technique for producing soft diffused shadows is to dampen the cast shadow area with clean water taking care to avoid disturbing any original colour underneath.

Then apply the shadow colour wet in wet, again ensuring that the shadow is painted from the object outwards. The softer graduated effect is shown in this illustration.

NB. *In most instances it is advisable to complete paintings and then add the shadows.*

Conclusion

There are no hard and fast rules regarding the painting of shadows. To a certain extent the shadow colour you mix or the glaze you use may be dependent upon the colour being painted over. Eg a blue glaze to act as a shadow over a green grass area may work quite well.

It will be evident from the various suggestions and illustrations in this chapter that much thought and consideration, not to mention experimentation, are worthwhile to master this important aspect of our paintings. Always try to work quickly and confidently using as few brush strokes as possible.

Balcombe, Sussex

Let us look at the implications of shadows in this painting (Fig 1) of Balcombe, Sussex.

It is evident that the light in this painting is coming from the left hand side.

The hard edged shadows in the foreground indicate strong sunlight.

Also note that the shadow on the wall (Fig 1a) is graduated in tone throughout its length. This gives the effect of it being a curved wall. This effect has been achieved by using Technique C.

Fig. 1a

Fig. 1

Note the cast shadow on the roof to the right of the area of shadow on the chimney stack. See Fig. 2a

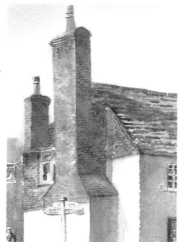

Fig. 2a

The buildings on the left hand side of the picture are in an area of shadow. (Fig. 3a)

This effect has been achieved by means of a glaze of a mixture of Cobalt Blue + Light Red over the buildings concerned. (ie Technique A)

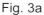

Fig. 3a

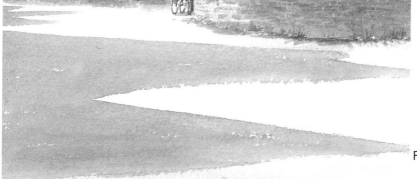

The cast shadows in the foreground (Fig. 4a) indicate the presence of other buildings somewhere out of sight on the left hand side.

These foreground shadows assist in forming a strong base to the picture. They add depth and interest to what might otherwise be a bland area of colour.

Fig. 4a

Balcombe, Sussex
continued

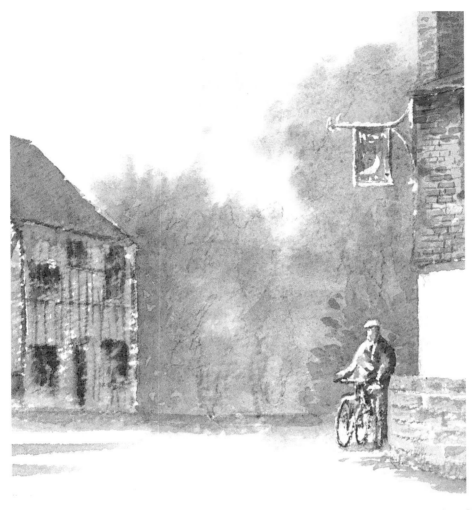

Although the man with a bicycle occupies but a small area of the painting, he is very much a focal point. As such it is important that the counterchange between light and shade should be well depicted.

Masking fluid was applied on the left hand side of the figure, prior to painting, to help isolation of the man from the surroundings on the left hand side which happen to be in an area of shadow. The dark tones of his clothing enabled 'Technique C' to be used, after removal of the masking fluid, to produce the gradation of tones which provide the required modelling of the figure.

The adjacent bushes in the background are in an area of shadow which was treated overall with a series of glazes of Cobalt Blue. (Technique A).

NB. I cannot stress too strongly the need for any existing paint , be it the original colour or subsequent glaze, to be absolutely dry before the application of a first or further glaze.

It will be apparent from the comments in these last two pages that shadows are an extremely powerful tool in any artist's armoury.

Shadow Showcase

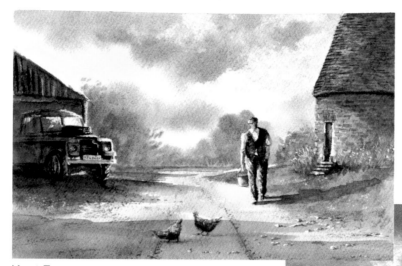

Kent Farm

Penhurst, Near Battle, Sussex

'Red Lion', Brede, Sussex

Balcombe, West Sussex

Shadow Showcase

Langstone Mill, Hampshire

Brightling Church, Sussex

Hastings Old Town
Sussex

Farm at Pett, Sussex

Oasts at Icklesham, Sussex

Putting it all Together

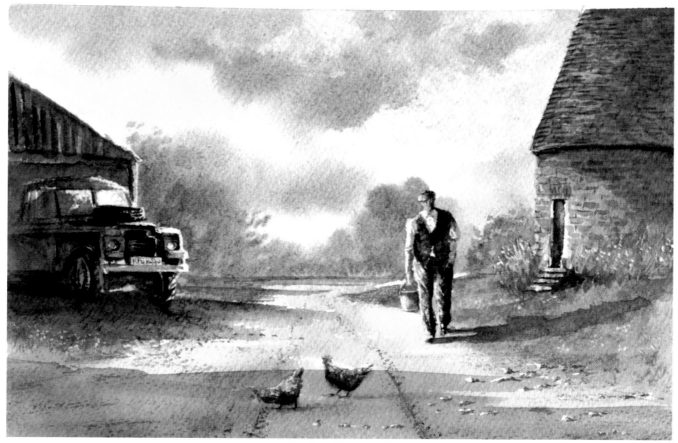

Fig.1　Farmyard

W̲e have touched upon many things, techniques, brushwork, tips and planning all of which are designed to help us with our painting. So far we have tended to consider these aspects in isolation from each other and perhaps we may now attempt to see them in unison, so to speak, through the medium of this picture of a farmyard.

Let us consider its component parts and their relevance to the issues outlined earlier.

The Sky

I used the wet in wet process in conjunction with a fluid consistency wash of Raw Sienna and a medium consistency mix of French Ultramarine Blue + Light Red.

The application of the cloud colour while the sky area is still damp enabled me to produce the soft and the more positive edges to the clouds.

I cannot emphasise too strongly the need for preparing all required colour washes and mixes prior to commencement of painting when using the wet in wet approach.

Putting it all Together -continued

Distant Bushes

Once again I adopted the wet in wet approach. By dropping in various shades of colour it was possible to provide modelling within the bushes.

Blues were introduced as part of of the wet in wet procedure to produce the shadows.

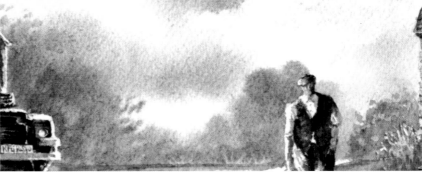

The Farmer
The very considerable modelling in the figure was achieved with the use of masking fluid and 'Technique C'.

Masking fluid was applied to the sunlit side of the figure prior to the painting stage. The clothing colours were applied to the right hand shadow side and 'Technique C' was used following removal of the masking fluid.

The Oast

Note that the roof contains a number of colours which I dropped in whilst previous colours were still damp. This has helped to give an impression of age and weathering.

In contrast the colours of the brickwork on the wall were painted when each previous colour was thoroughly dry.

The roof and wall shadows were achieved with successive glazes of blue.

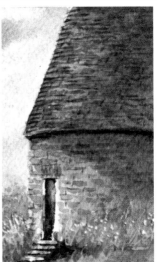

Landrover

This area of the picture is strong and adds impact to the overall effect.

Prior to the painting stage masking fluid was used to ensure maintenance of the highlights on the windscreen and other areas of the vehicle.

The shed and vehicle are both in an area of shadow which has been depicted by the use of varying mixtures of blue and Light Red.

In particular note the separation between the shed, vehicle and the background bushes, created by tonal changes.

Finally you will note from the cast shadows thrown by the shed and landrover that the adjacent ground slopes slightly away from the shed.

Putting it all Together-_{continued}

Shadows

The cast shadow thrown by the figure follows the rule outlined earlier in that it has assumed the contours of the adjacent ground. It is quite evident that the ground slopes upwards towards the oast.

'Technique A' (ie Glazing) was used to depict the farmer's shadow.

The small area of shadow to the immediate right of the steps assists in giving the latter adequate modelling.

NB. Glazing is a straightforward process provided that the following points are observed:

1) That the previous application of paint is absolutely dry.

2) That the brush must cover each area once only.

Observance of the above will help to prevent previous colour or detail from being disturbed.

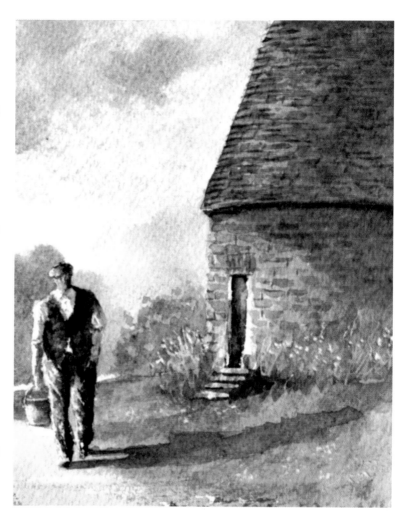

Shadows

Note the significant shadow in the immediate foreground. This is obviously cast by something outside the perimeter of the picture.

It plays an important role in that it provides relief from the colour of the pathway thereby preventing the bottom quarter or so of the painting from being somewhat dull and uninteresting. Again I used 'Technique A' to insert the shadow.